ALSO BY BARBARA NORFLEET

Looking at Death (1993)

Manscape with Beasts (1990)

All the Right People (1986)

Killing Time (1982)

The Champion Pig (1979)

Wedding (1979)

THE ILLUSION OF ORDERLY PROGRESS

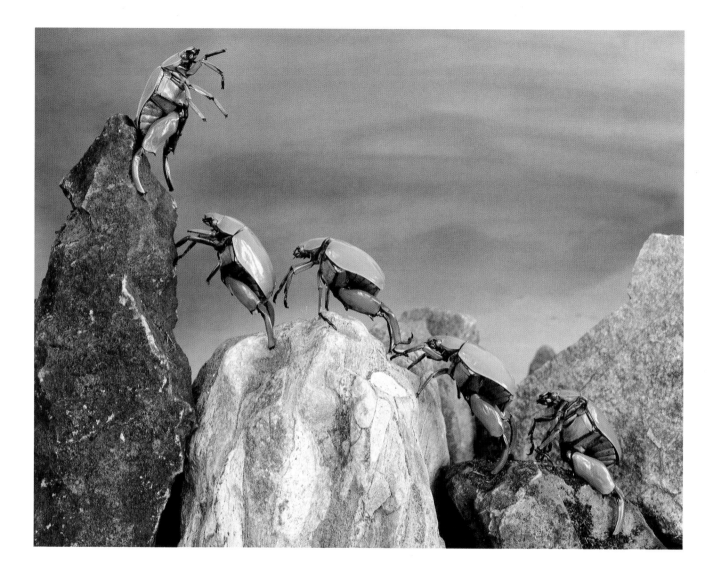

The Illusion of Orderly Progress

BARBARA NORFLEET

WITH A FOREWORD BY EDWARD O. WILSON

ALFRED A. KNOPF

NEW YORK

1999

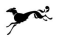

THIS IS A BORZOI BOOK
PUBLISHED BY ALFRED A. KNOPF, INC.

Library of Congress Cataloging-in-Publication Data
Norfleet, Barbara P.
 The illusion of orderly progress / by Barbara Norfleet ; with a foreword
by Edward O. Wilson. — 1st ed.
 p. cm.
 ISBN 0-375-40558-5 (hc. : alk. paper)
 ISBN 0-375-70531-7 (pbk. : alk. paper)
 1. Photography of insects. 2. Insects—Pictorial works. 3. Photogra-
phy, Artistic. 4. Norfleet, Barbara P. I. Title.
TR729.I6N67 1999
779'.3257—dc21 98-38187
 CIP

Manufactured in Singapore
First Edition

Frontispiece: Glory
Facing the foreword: There's Nothing — No, NOTHING — That's Higher Than Me
Facing page 1: Is This All There Is?

FOR ALEX, ANDY, CAITLIN, CHASE, DYLAN, AND HANNAH

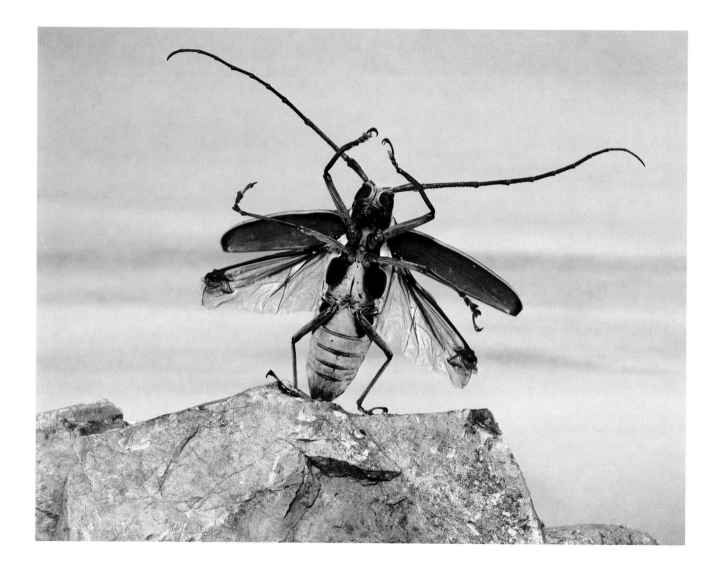

Foreword

EDWARD O. WILSON

Barbara Norfleet's entomological compositions are strikingly creative. Like all true art, they draw us to their interior while stirring strange remembrance at multiple levels. Although by habit of thought I am by no means a deconstructionist, I confess to being idiosyncratic in response to these images. To wit, I am an entomologist, so my first reaction was to identify and put scientific names on the insects. None displayed is repugnant to me, as they might be to many others. While the great majority of Norfleet's subjects are dead—dried specimens ready for museum cabinets (otherwise, how could she have posed them?)—they were once organic machines exquisitely designed for the environments in which they lived. In Norfleet's hands they serve a new purpose.

Look closely at them. Most are beetles, an appropriate choice given that Coleoptera are the most diverse of all living creatures. Most are also collector's items, belonging to species prized variously for large size, bright colors, lacquered carapaces, and bizarre spines, horns, and other armaments used chiefly by males to fight over females. One can muse indefinitely in this direction.

But I risk too much digression from Norfleet's main purpose. The artist means to tell us something about human nature, particularly in its more vainglorious, cowardly, and other foolish manifestations. She accomplishes her goal through the time-honored device of the animal fable—though rather than symbol-laden rabbits, wolves, and serpents, she uses true aliens, bizarre tropical insects purchased from supply houses. Thus, instead of commuters on a freeway, we get scarab beetles circling up and down on a featureless hillock. A charismatic leader at a political rally—or is it an evangelist preaching to his flock?—becomes a grasshopper ecstatically posed before an audience of beetles (to be precise—may I?—buprestids, lucanids, and one cerambycid). A coleopterous mountain climber stands atop a conquered peak, but it is only a dismissible fragment of rock. In general, easily recognizable foibles are expressed not with images of our precious and lovable selves, which invite instant familiarity and forgiveness, but with strangers whose behavior can be pitilessly and thus honestly scrutinized. That is human nature: Let others draw contempt for the weaknesses we know dwell in ourselves.

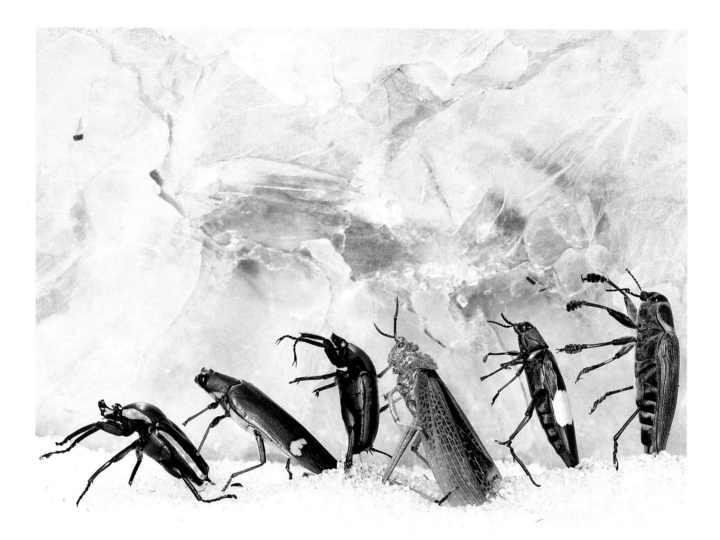

THE ILLUSION OF ORDERLY PROGRESS

My People

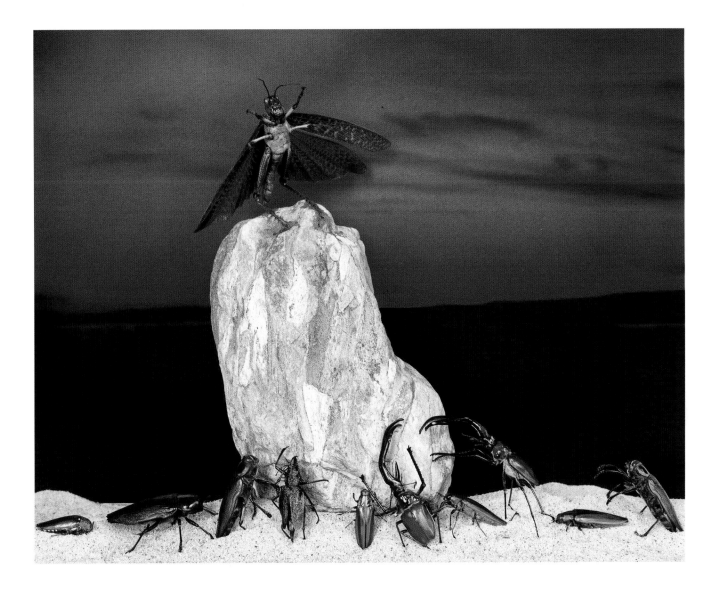

Surveillance

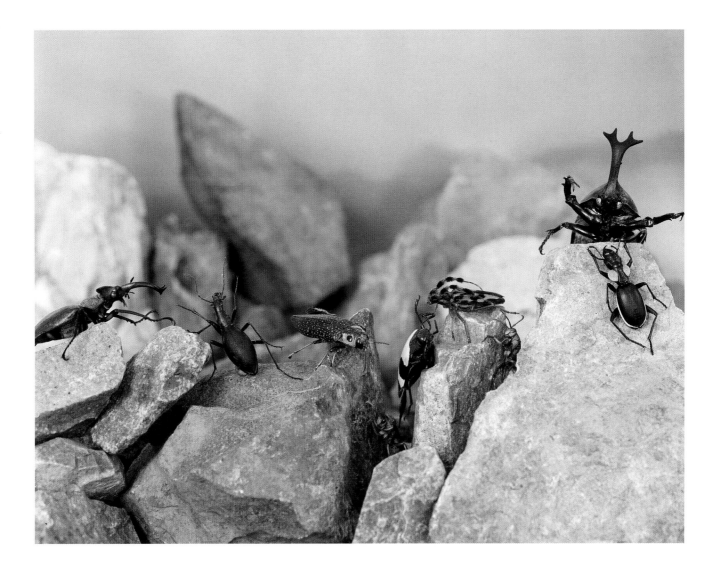

Lying Low

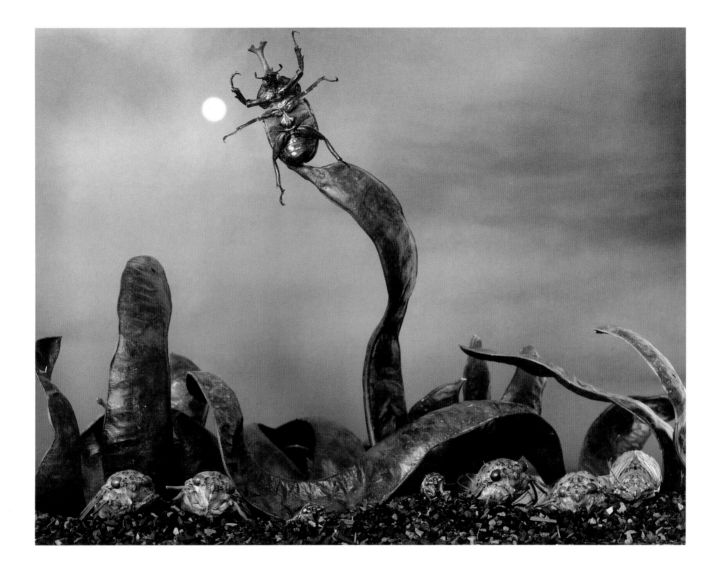

I Won't Deny My Nature

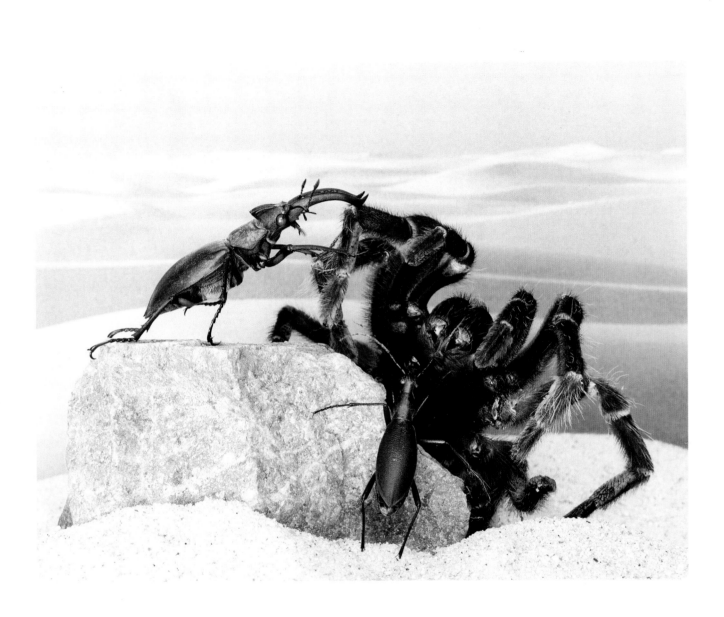

The Flesh Eaters

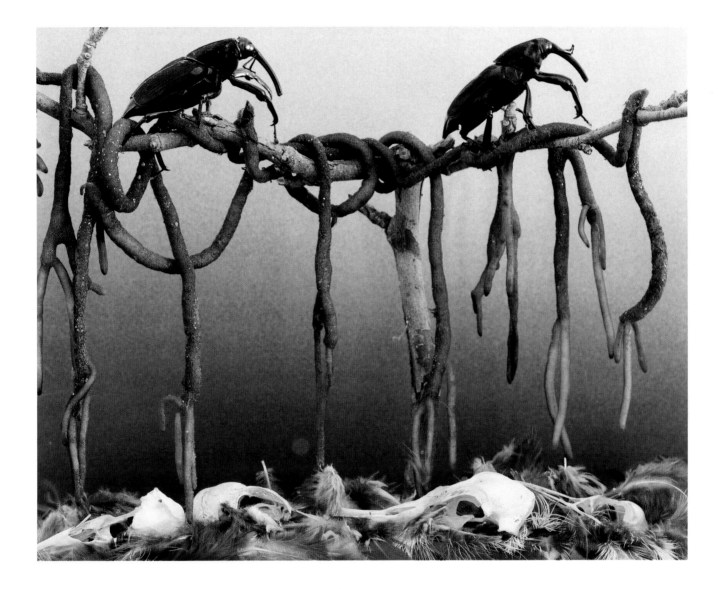

Expectation of Submission

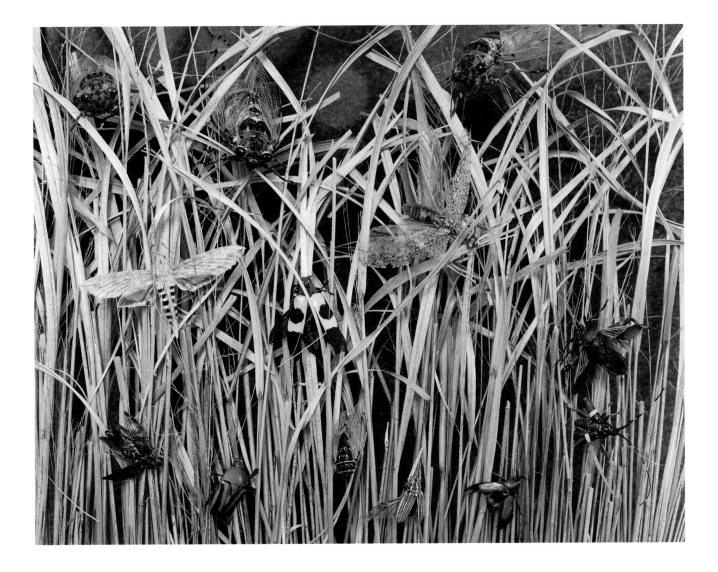

Sorry—All Ants Look Alike to Me

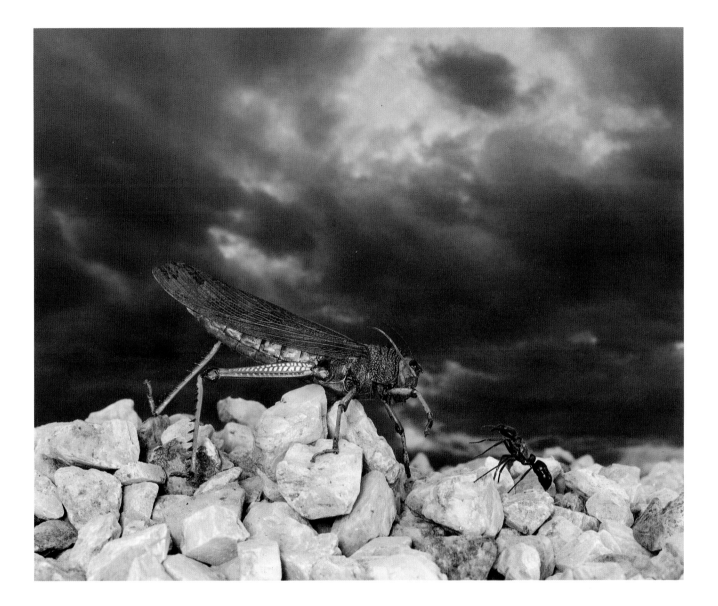

We Don't Go for Strangers

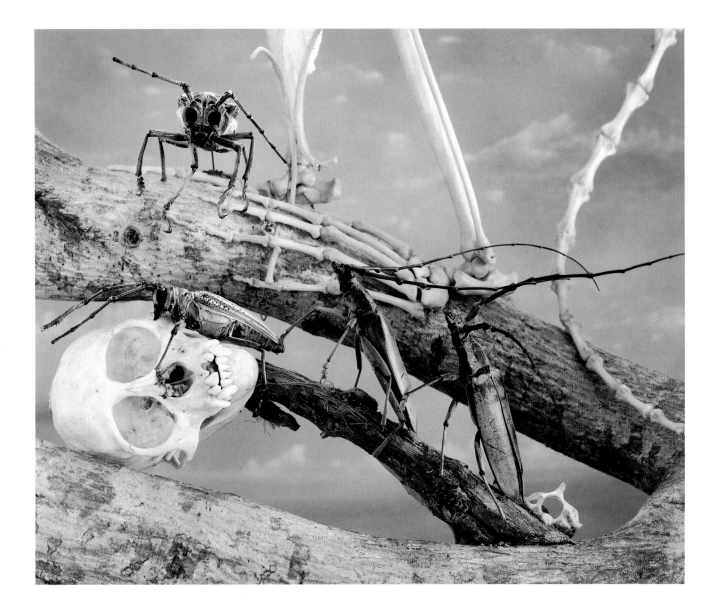

Color Bar

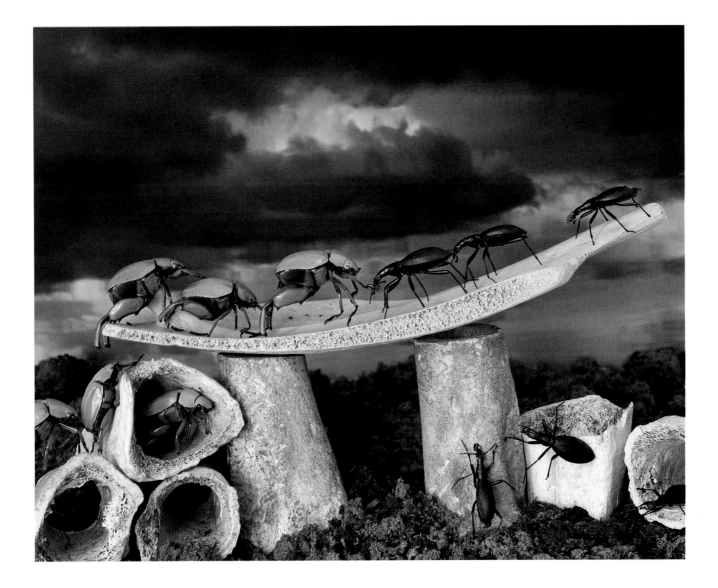

My Tribe Is Better Than Your Tribe

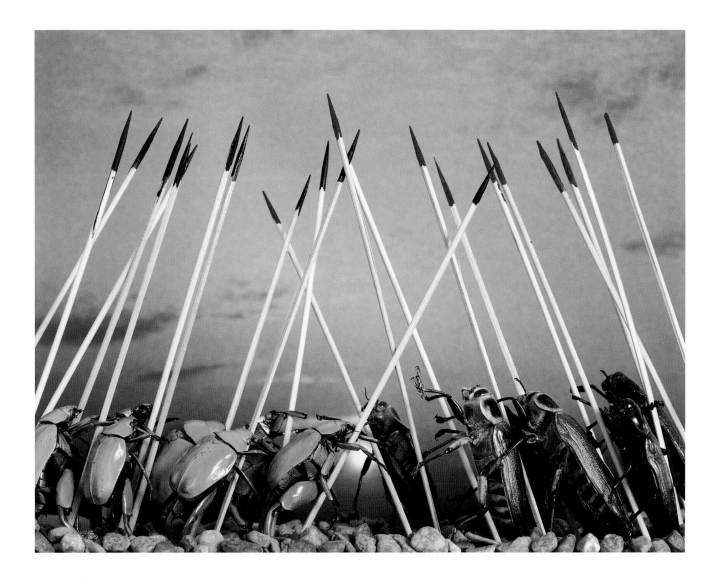

Go Back to Your Homeland

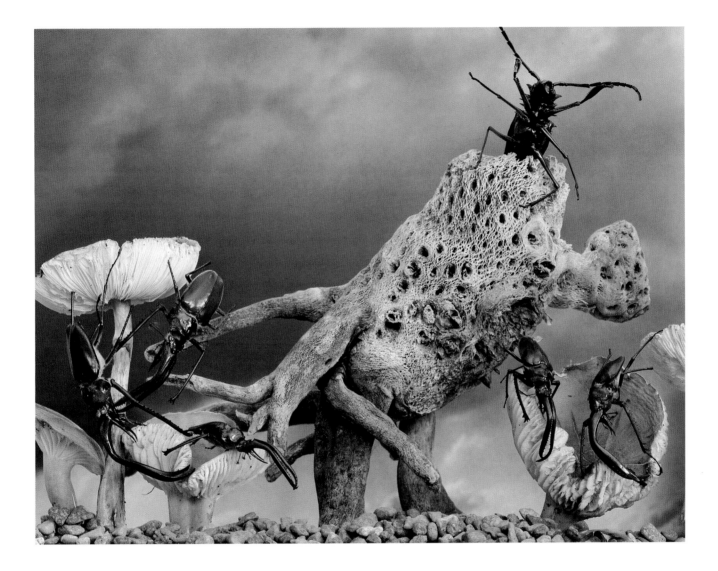

It Was About Respect

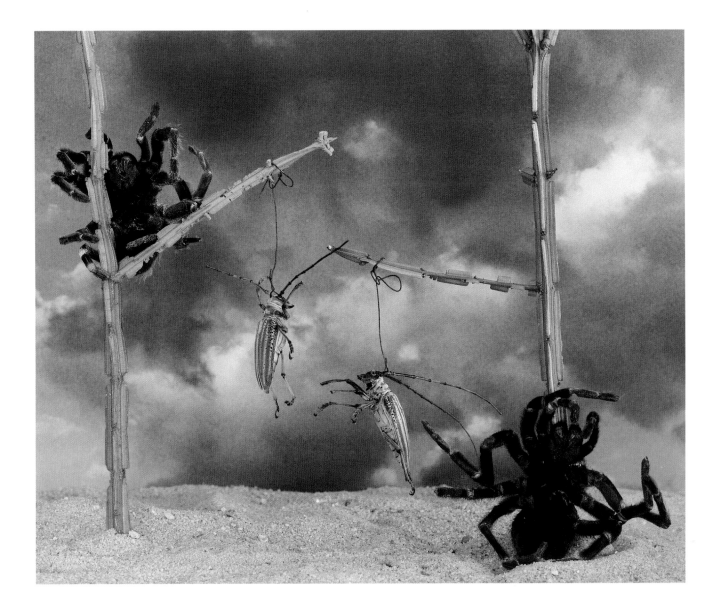

The End of the Greens

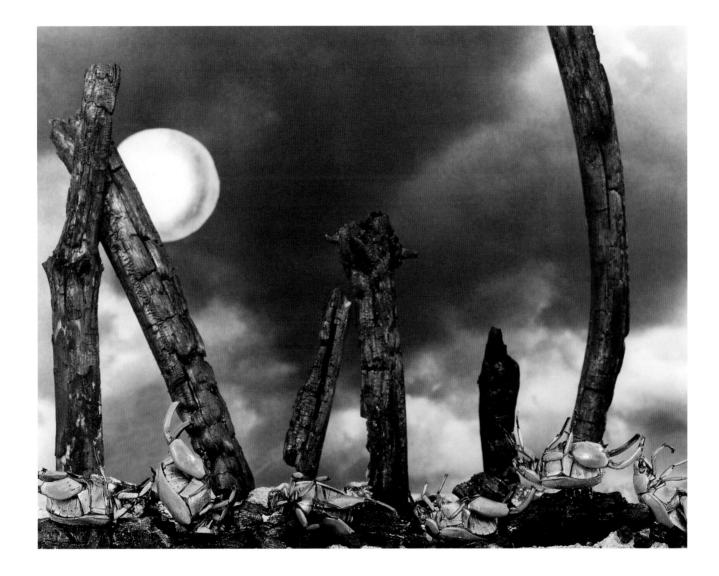

Domestication #1

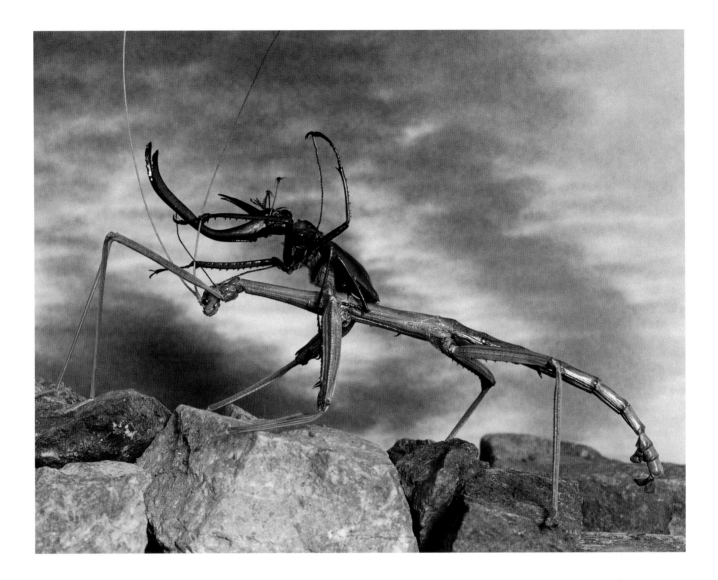

Domestication #2

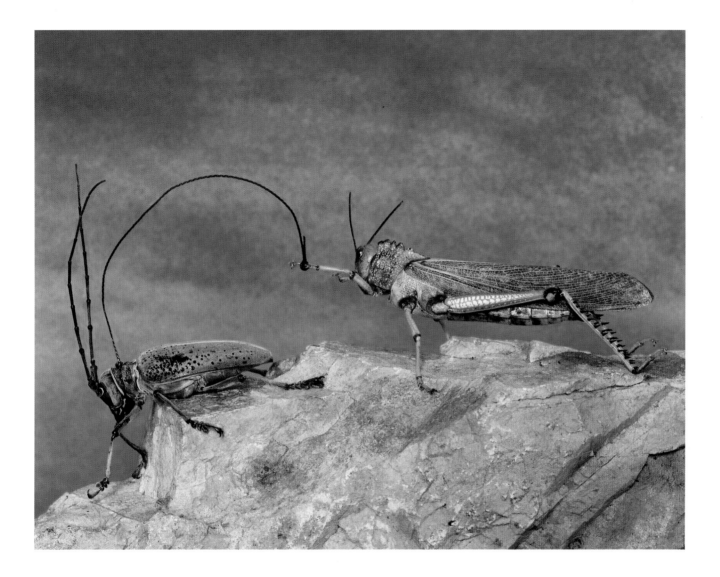

Toys

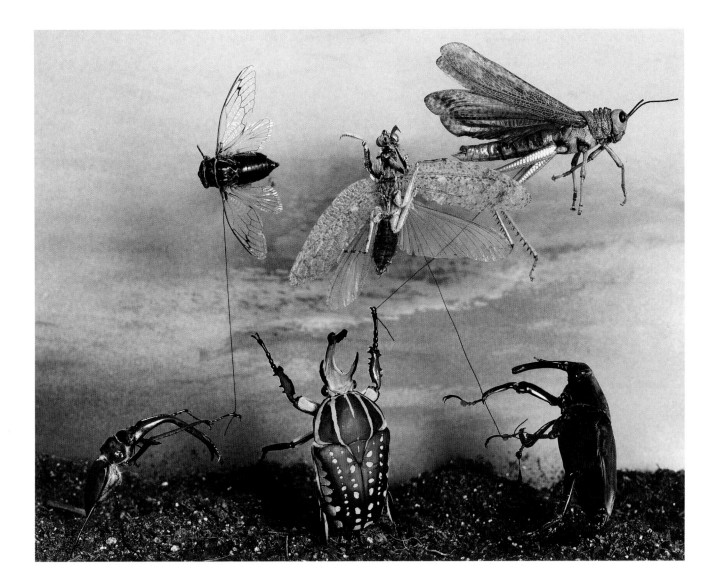

Sport

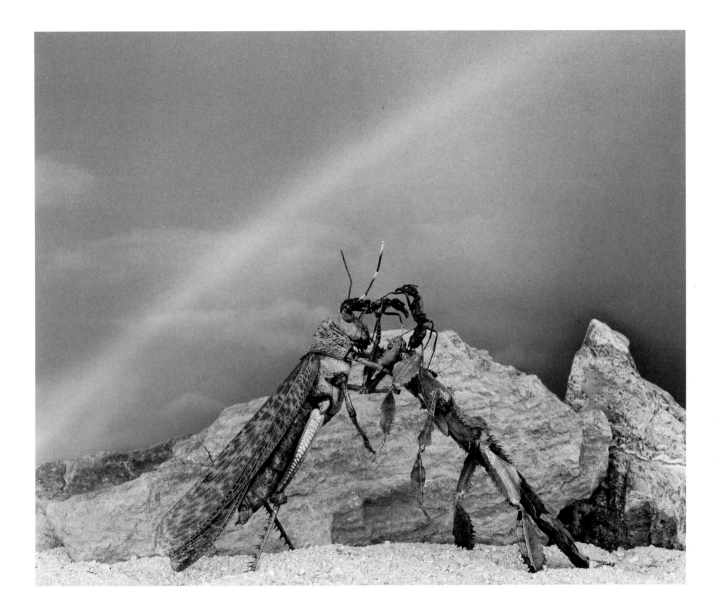

Frolic

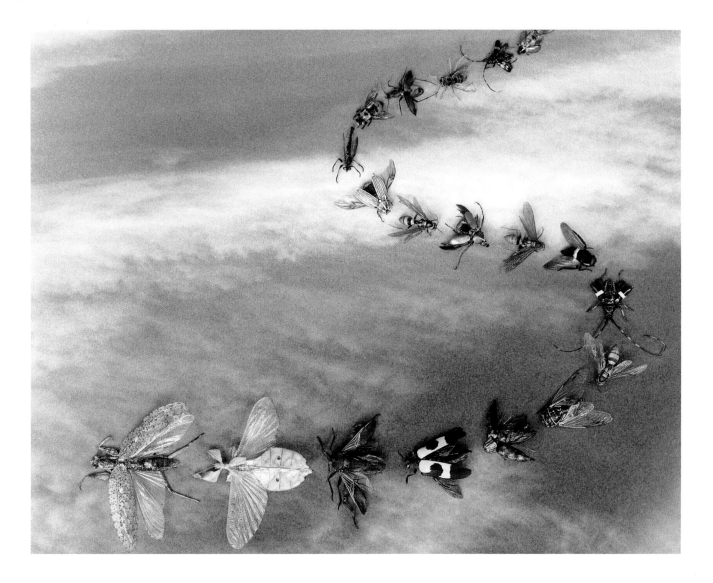

The Garden of Earthly Delights

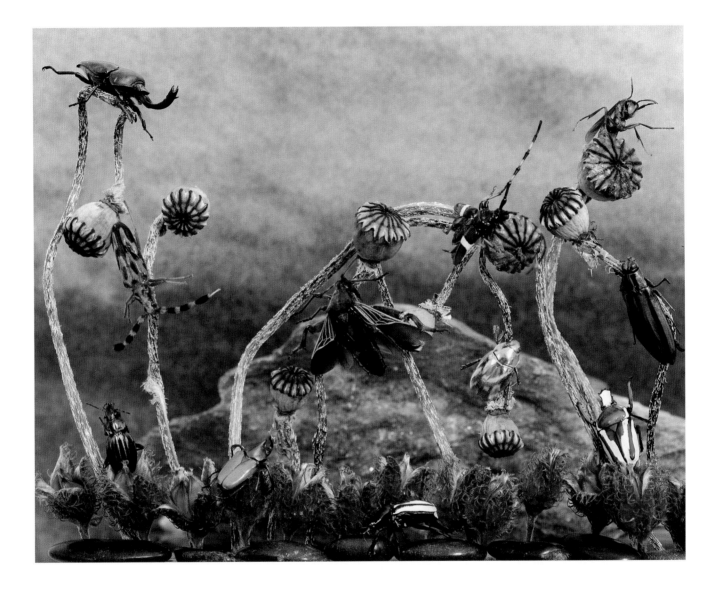

Little Time for Whimsy

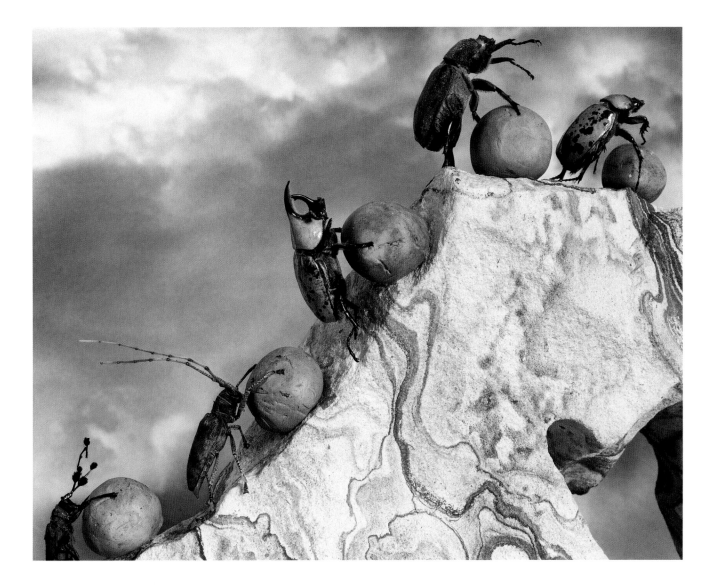

The Illusion of Orderly Progress

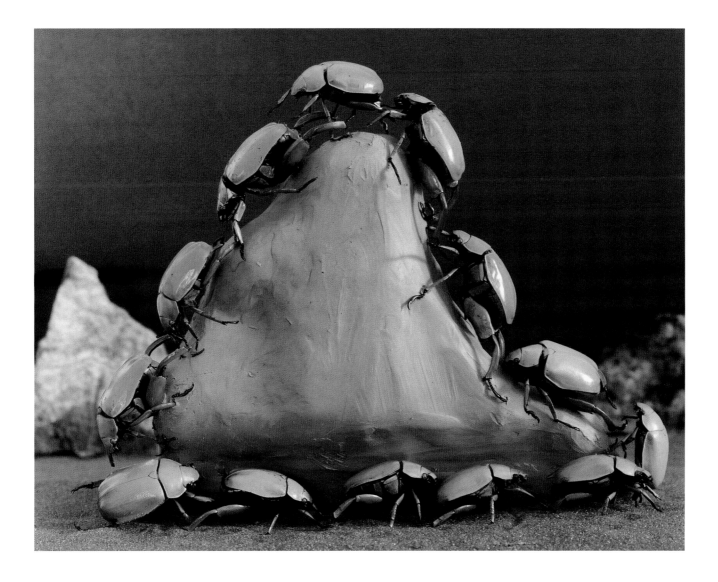

Am I Pretty?

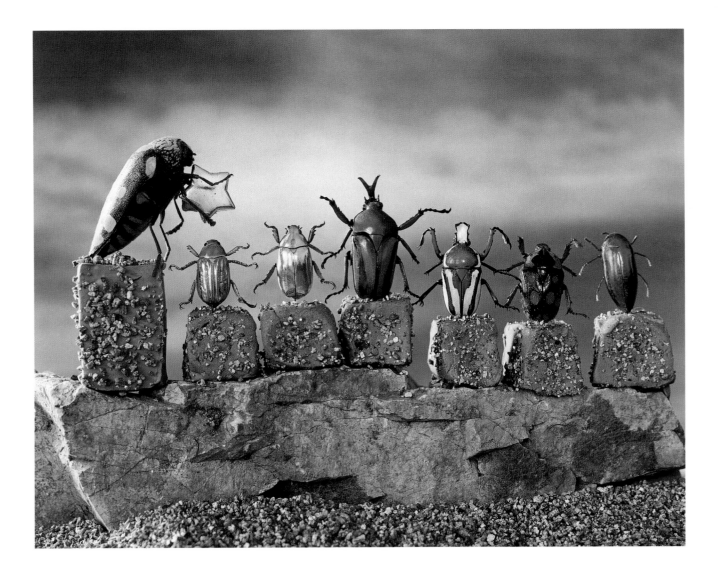

Who Is the Fairest of Them All?

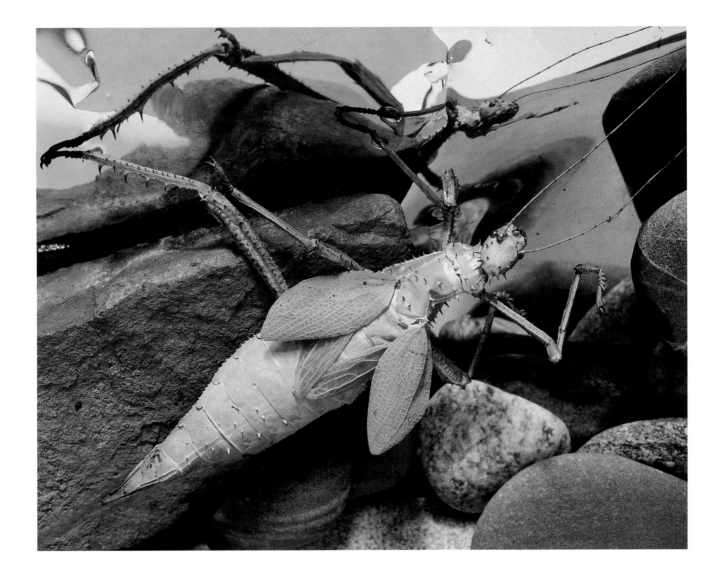

"How's Yellow Eyes?" "Give My Best to Goldie." "Say Hi to Bitey." "Have You Seen Shine Lately?" "Looks Like Long Legs's Wife Has Left Him." "Give Poison a Hug for Me." "You Look Dashing."

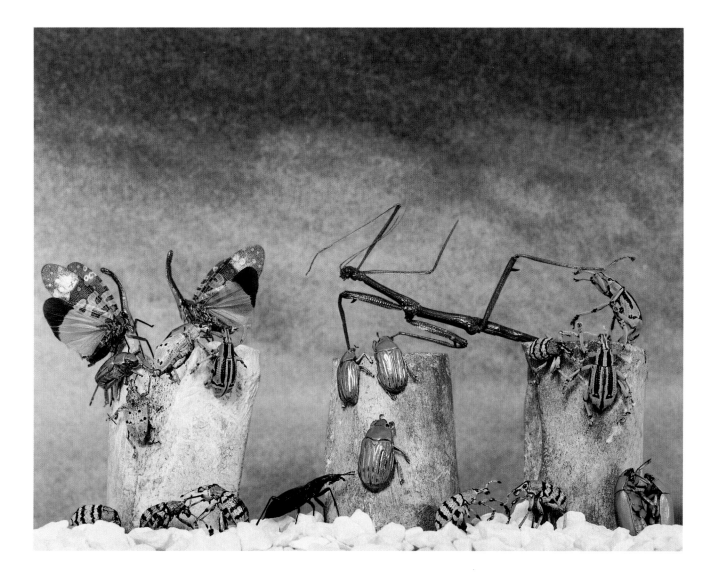

Dance Betrayal

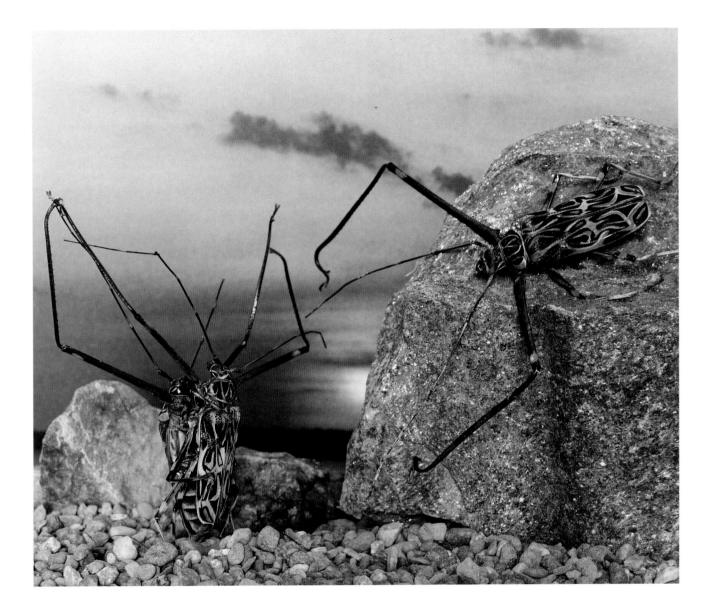

Deception

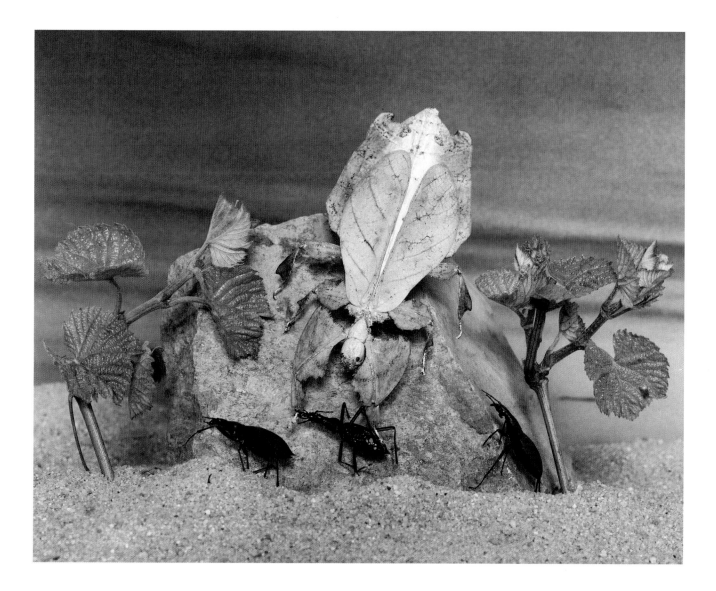

The Myth of Coupling

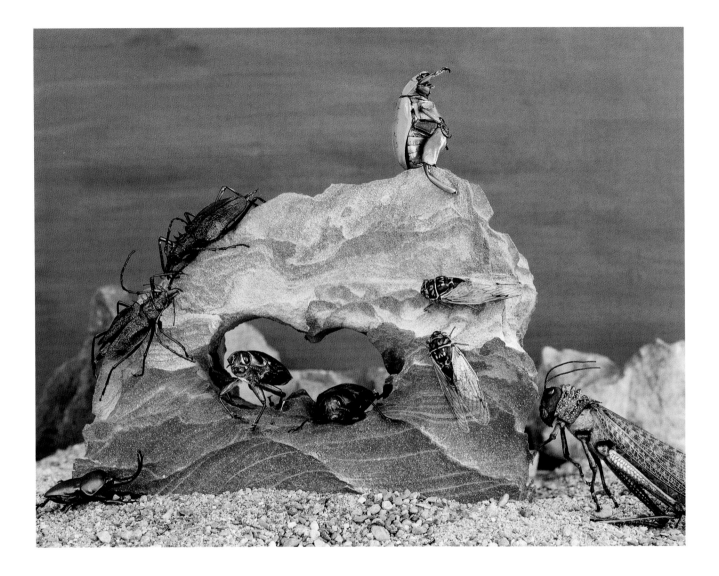

Saturday Night

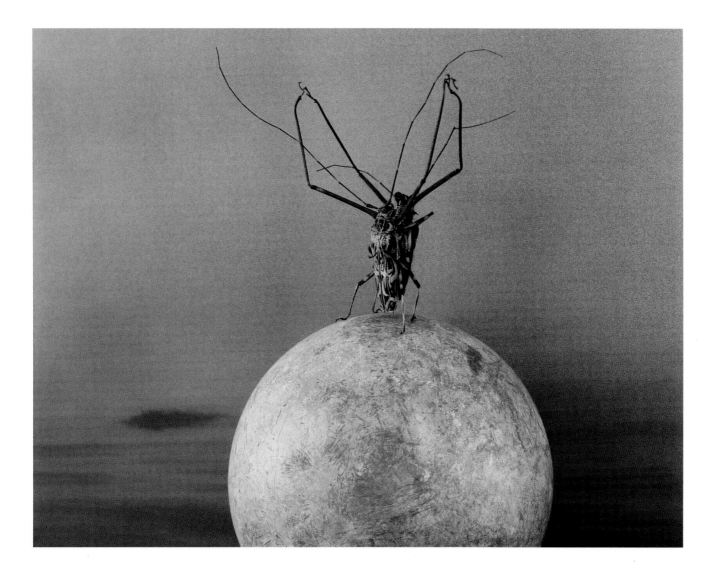

Mine

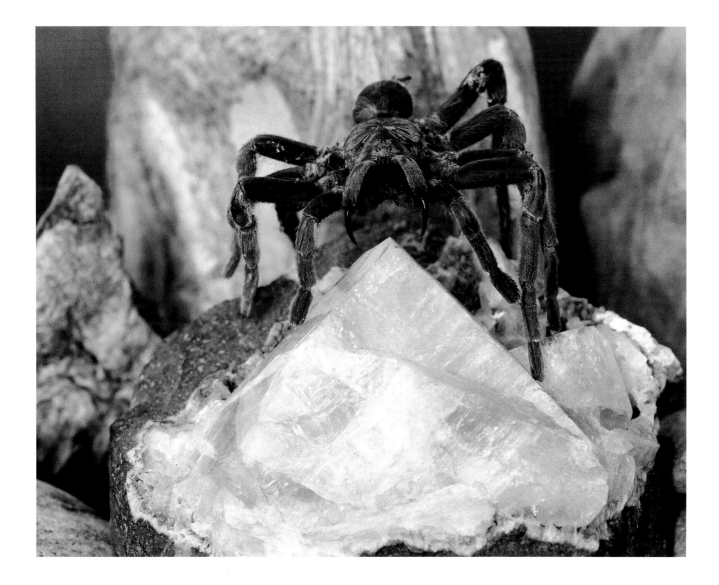

Real Estate

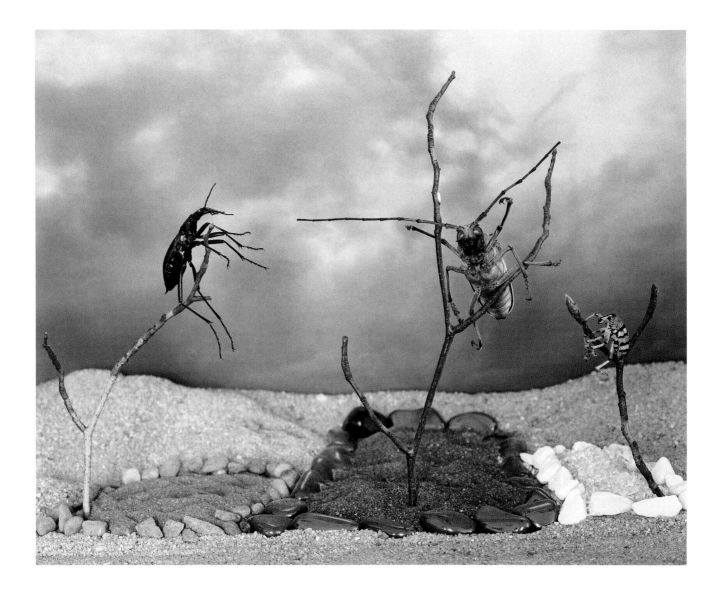

The Crossing

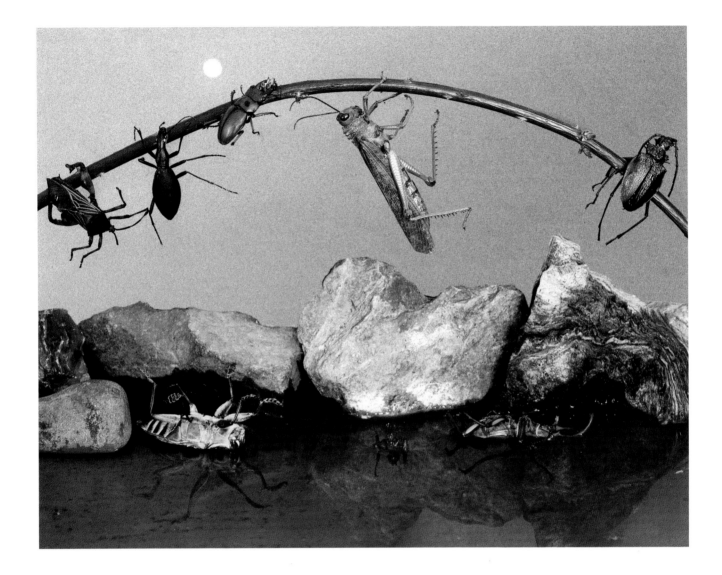

Rain Follows the Plow

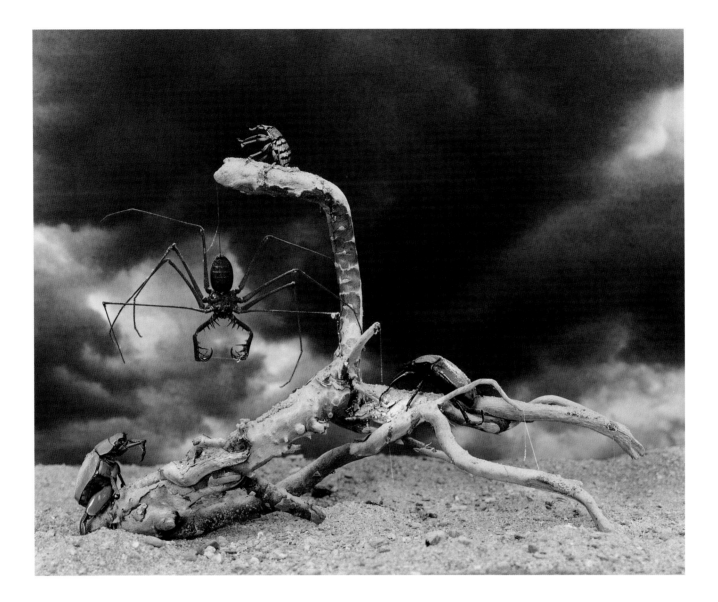

The Sense of Failed Expectations

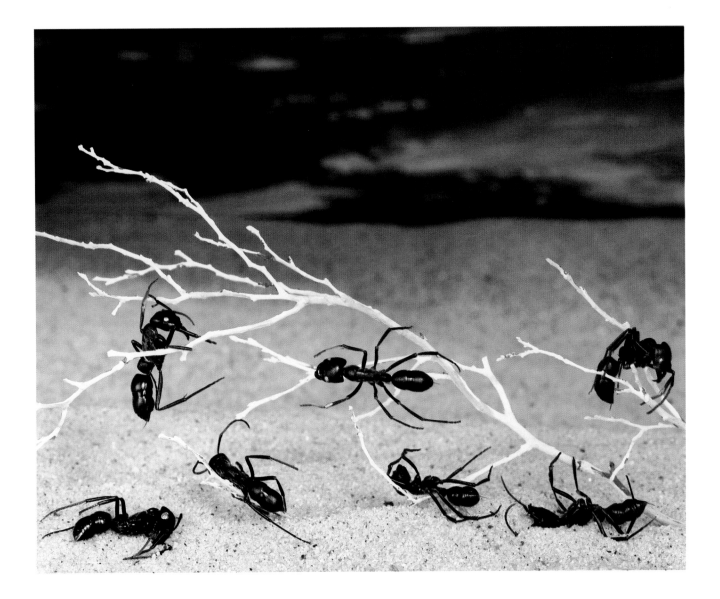

A Landscape So Lone

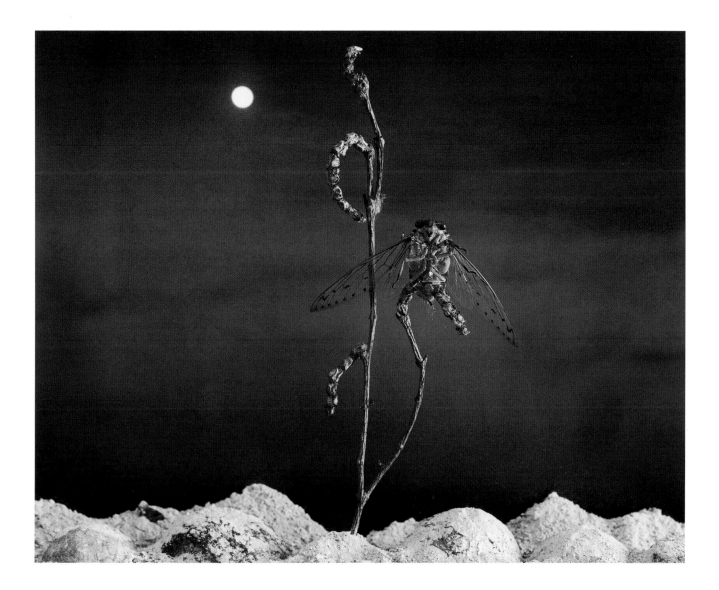

Of Course We Prayed

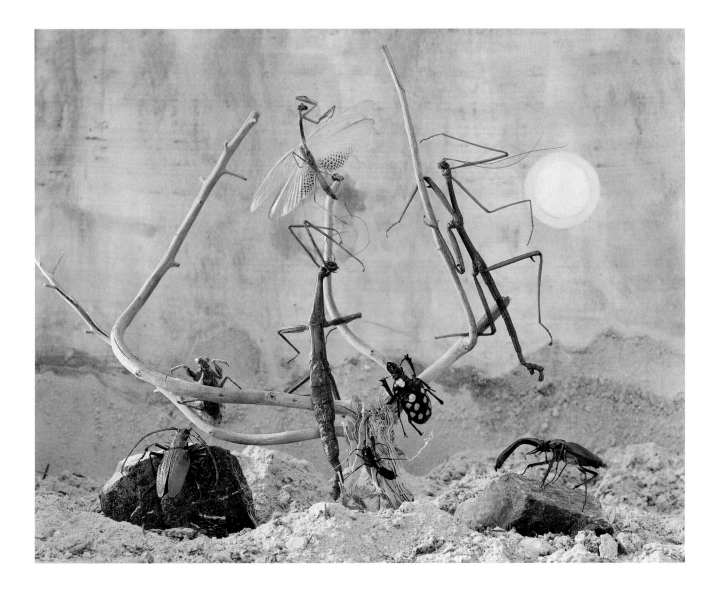

Being Over Nothingness

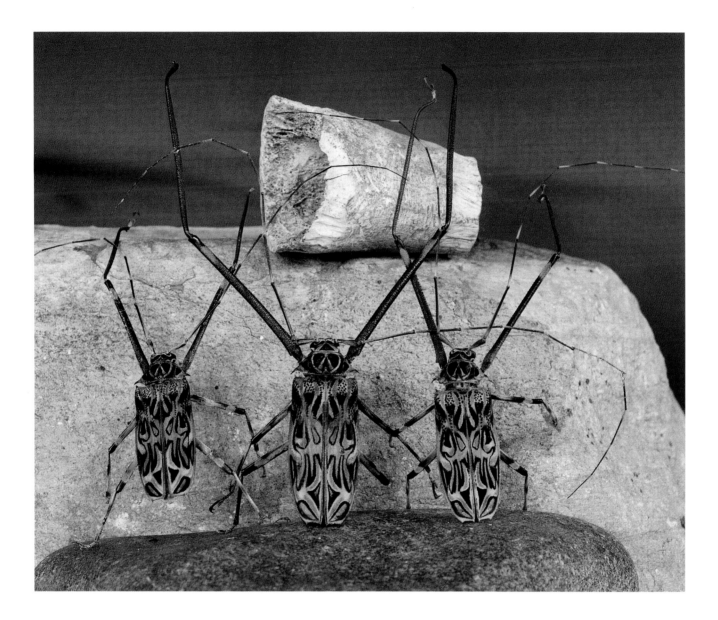

A Promise of Tomorrows

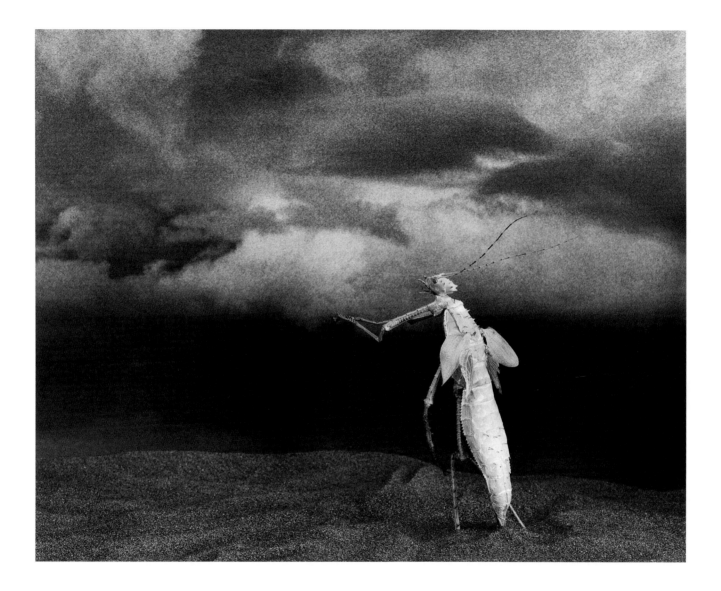

Political World Rattle

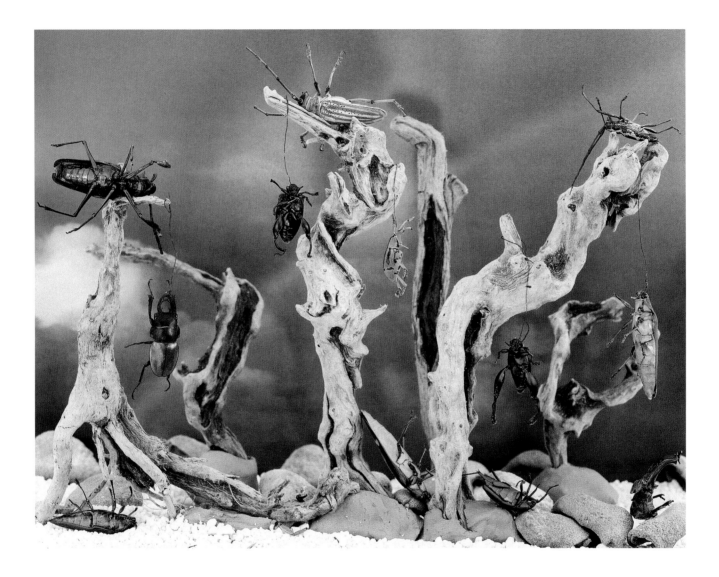

The Babble of Captives

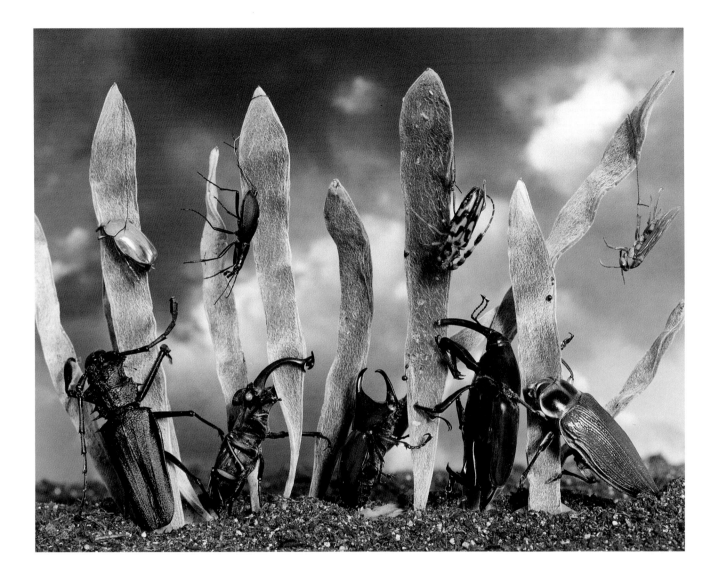

There Will Never Be Another War

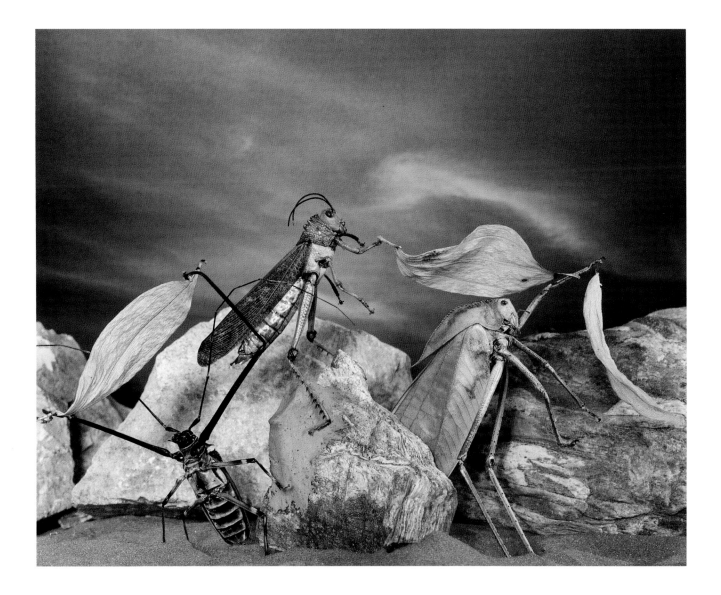

Heroes

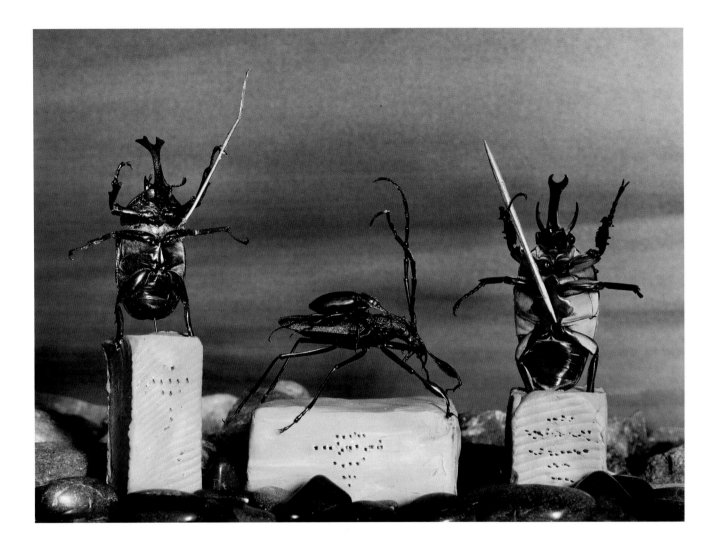

Justice

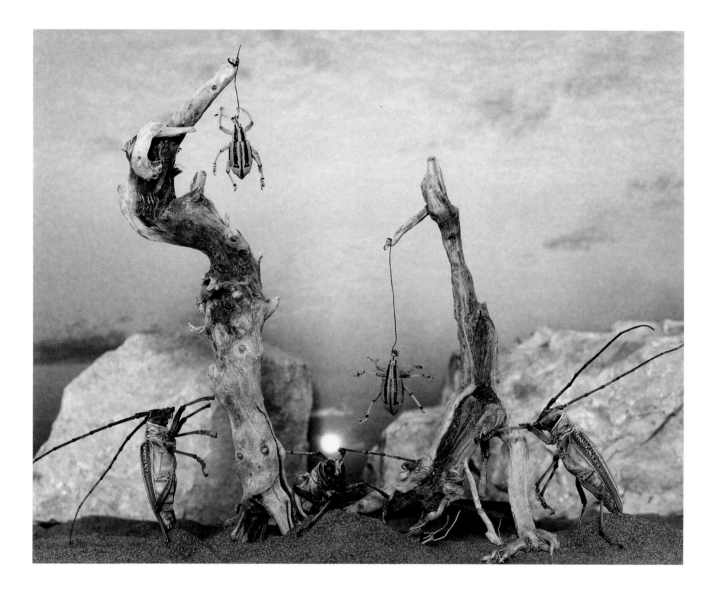

Ship of Fools

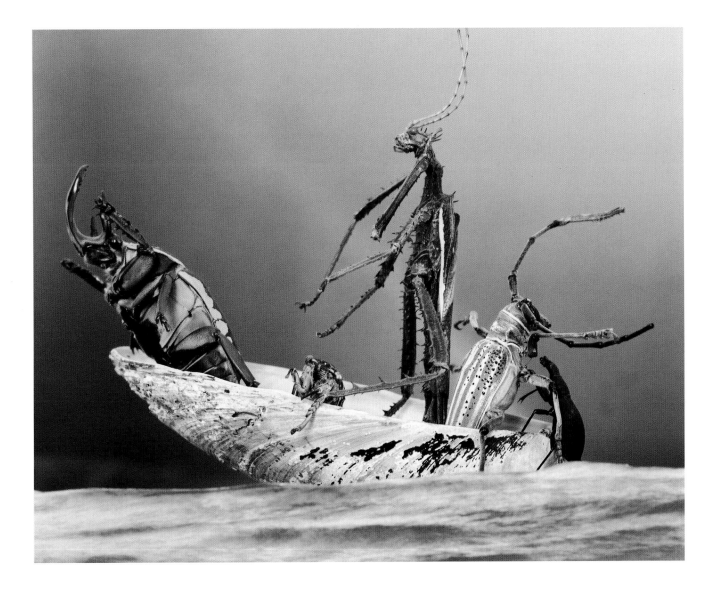

Yet Another Postmodern Sunset

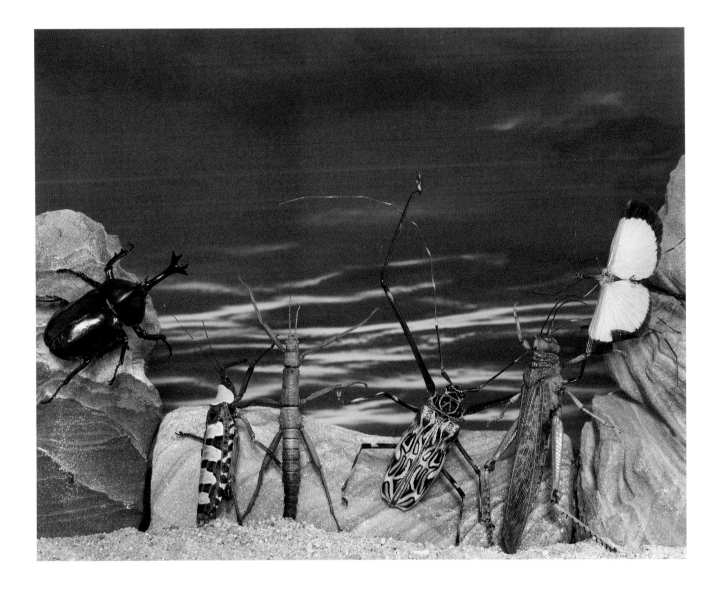

Untitled

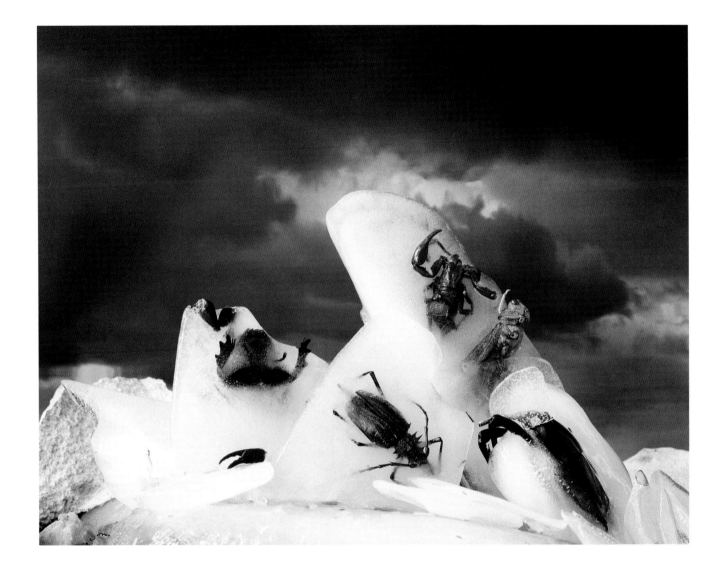

Author's Note

The Museum of Comparative Zoology (MCZ) at Harvard University is a nineteenth-century museum. It contains case after case of exotic shells, sparkling minerals, beautiful birds, mangy stuffed animals, impressive bones, and sublime insects. From the time they could walk I took my children to this old, dusty museum to spend hours examining those cases.

They didn't know it was a boring museum until the opening of the Museum of Science, which featured a working model of Leonardo's water-lifting pump, gears that interconnected in dozens of strange ways, balls that did fantastic stunts when you pushed a button, an owl that flew around the room in total silence. Later, computers entered.

But the MCZ somehow touched their imaginations. They won first prizes for their insect collections year after year at a local fair. Now I love to hear them tell their own children, "Look at the cecropia moth," "That's a mantis," "Hear the June bug." My children no longer enter contests. But one grandchild will not let me kill a bug.

Animals have always sneaked into my photographs. A project on a colorful bachelor emphasized his dog; one on the hidden upper class resulted in boxes of horse pictures; and my nuclear bomb piece had coyotes wandering into radioactive areas. I did a book on raccoons, rats, skunks, and other animals in people's debris—our pills, our discarded cars, our abandoned structures.

The animal project placed me in nature for much of every day. A perfect project. The nuclear bomb images portrayed the power of man to invade the wilderness and change it forever. Both taught me that the vanity and arrogance of my own species have strange impacts.

My desire to seek color, humor, and beauty, to never forget skies, to record wrongs, made insects a natural choice for the present project.

My wastebaskets became filled with false starts. Focusing a close-up lens for a fraction of a second on a moving, wiggling insect was impossible. A year's work gave me hundreds of negatives and three pictures.

I froze live Mexican cockroaches. I took the now dead roaches and put them on my desk to defrost

while I designed a tableau on my piano. I returned to my desk and found a fluid, moving top made up of armies of big black ants carrying off pieces of my roaches. The ants of Cambridge had waited not far away for this gourmet feast to arrive. Delicious meaty insects were not the solution.

I found an insect catalog, more like a telephone directory than an L.L. Bean—long lists but few pictures. You had to know your insects. They cost anywhere from fifty cents a dozen to $150 apiece.

My first order came. I was thrilled, but nervous. They were all dried up yet still marvelous. I knew how to bring them back to life.

More false starts I put them into paintings of significant political historical happenings—Joan of Arc at the stake or Adam and Eve after the Fall. Boring.

Next I used backdrops of landscapes I had photographed. Wrong again.

Only skies, rocks, and sand seemed appropriate. My insects became the survivors in a barren world as they played out history.

The result is these photographs.

BARBARA NORFLEET

JULY 6, 1998

Insect Identities

- Identification goes from left to right and from top to middle to bottom.
- Sequence of identification: common name, species (in italics), order (in capital letters), family, subfamily, region of origin.
- Complete information is not available for every insect. There exist between 10 and 30 million insects, and only about 1 million have names. No one person knows all the million names.

My deepest thanks go to Geoffrey Morse, an entomologist with superb eyes and knowledge, for his untiring assistance in helping me identify the insects.

Glory (page ii)
Shining leaf chafer beetles *Chrysina macropus* (COLEOPTERA: Scarabaeidae: Rutelinae). Latin America

There's Nothing—No, NOTHING—That's Higher Than Me (page vi)
Flat-faced longhorn beetle *Batocera victoriana* (COLEOPTERA: Cerambycidae: Lamiinae). Malaysia

Is This All There Is? (page viii)
Flower chafer beetle *Dicronorhina derbyana* (COLEOPTERA: Scarabaeidae: Cetoniinae). Republic of South Africa
Metallic wood-boring beetle *Megaloxantha hemixantha* (COLEOPTERA: Buprestidae). Malaysia
Flower chafer beetle *Rhomborrhina splendida* (COLEOPTERA: Scarabaeidae: Cetoniinae). Taiwan
Short-horned grasshopper *Tropidacris dux* (ORTHOPTERA: Acrididae). Latin America
Metallic wood-boring beetle *Chrysochroa maruyami* (COLEOPTERA: Buprestidae). Thailand
Metallic wood-boring beetle *Euchroma gigantea gigantea* (COLEOPTERA: Buprestidae). Latin America

My People (page 3)
top:
Short-horned grasshopper *Tropidacris dux* (ORTHOPTERA: Acrididae). Latin America
bottom:
Metallic wood-boring beetle (COLEOPTERA: Buprestidae)
Metallic wood-boring beetle *Euchroma gigantea gigantea* (COLEOPTERA: Buprestidae). Latin America
Metallic wood-boring beetle *Euchroma gigantea gigantea* (COLEOPTERA: Buprestidae). Latin America
Tooth-necked longhorn beetle *Psalidognathus friendi* (COLEOPTERA: Cerambycidae: Prioninae)
Metallic wood-boring beetle (COLEOPTERA: Buprestidae)
Stag beetle *Chiasognathus granti* (COLEOPTERA: Lucanidae). Chile
Metallic wood-boring beetle (COLEOPTERA: Buprestidae)
Stag beetle *Chiasognathus granti* (COLEOPTERA: Lucanidae). Chile
Metallic wood-boring beetle (COLEOPTERA: Buprestidae)
Metallic wood-boring beetle *Euchroma gigantea gigantea* (COLEOPTERA: Buprestidae). Latin America

Surveillance (page 5)
top:
Rhinoceros beetle *Allomyrhina dichotomus taiwana* (COLEOPTERA: Scarabaeidae: Dynastinae). Taiwan
bottom:
Stag beetle (COLEOPTERA: Lucanidae)
Ground beetle *Damaster blapoides montanus* (COLEOPTERA: Carabidae). Japan
Metallic wood-boring beetle (COLEOPTERA: Buprestidae)
Aztec wasp *Polistes carnifex* (HYMENOPTERA: Vespidae). Mexico and South America
Metallic wood-boring beetle *Chrysochroa buqueti* (COLEOPTERA: Buprestidae)
Roundneck longhorn beetle *Natus barbicornis* (COLEOPTERA: Cerambycidae: Cerambycinae)

Aztec wasp *Polistes carnifex* (HYMENOPTERA: Vespidae). Mexico and South America

Ground beetle *Anthia massilicata* (COLEOPTERA: Carabidae). Zimbabwe

middle:

Flat-faced longhorn beetles *Rosenbergia weiskei* (COLEOPTERA: Cerambycidae: Lamiinae). Papua New Guinea

bottom:

Tarantula *Euryelma* sp. (ARANEA). United States

The End of the Greens (page 27)

Shining leaf chafer beetles *Chrysina macropus* (COLEOPTERA: Scarabaeidae: Rutelinae). Latin America

Domestication #1 (page 29)

top:

Stag beetle *Chiasognathus granti* (COLEOPTERA: Lucanidae). Chile

bottom:

Walkingstick *Megaphasma denticrus* (ORTHOPTERA: Phasmatodea: Phasmatidae). United States

Domestication #2 (page 31)

Flat-faced longhorn beetle *Rosenbergia weiskei* (COLEOPTERA: Cerambycidae: Lamiinae). Papua New Guinea

Short-horned grasshopper *Tropidacris dux* (ORTHOPTERA: Acrididae). Latin America

Toys (page 33)

top:

Cicada (HOMOPTERA: Cicadidae)

Mantid (ORTHOPTERA: Mantodea: Mantidae)

Short-horned grasshopper *Tropidacris dux* (ORTHOPTERA: Acrididae). Latin America

bottom:

Stag beetle *Chiasognathus granti* (COLEOPTERA: Lucanidae). Chile

Flower chafer beetle *Chelorrhina polyphemus confluens* (COLEOPTERA: Scarabaeidae: Cetoniinae). Zaire

Giant weevil *Macrochirus praetor* (COLEOPTERA: Curculionidae: Curculioninae). Malaysia

Sport (page 35)

top:

Giant Amazon ants *Dinoponera quadriceps* (HYMENOPTERA: Formicidae). Brazil

bottom:

Short-horned grasshopper *Tropidacris dux* (ORTHOPTERA: Acrididae). Latin America

Walkingstick *Extatosoma tiratum* (ORTHOPTERA: Phasmatodea: Phasmatidae). Australia

Frolic (page 37)

from left:

Mantid (ORTHOPTERA: Mantodea: Mantidae)

Walking leaf insect *Phyllium gigateum* (ORTHOPTERA: Phasmatodea: Phyllidae). Malaysia

Leaf-footed bug *Thasus gigas* (HETEROPTERA: Coreidae). North America

Metallic wood-boring beetle *Chrysochroa buqueti* (COLEOPTERA: Buprestidae). Thailand

Metallic wood-boring beetle (COLEOPTERA: Buprestidae)

Cicada (HOMOPTERA: Cicadidae)

Aztec wasp *Polistes carnifex* (HYMENOPTERA: Vespidae). Mexico and South America

Roundneck longhorn beetle *Trachyderes succinctus* (COLEOPTERA: Cerambycidae: Cerambycinae). Brazil

Tangle-veined fly *Hirmoneura brevirostrata* (DIPTERA: Nemestrinidae). Chile

Aztec wasp *Polistes carnifex* (HYMENOPTERA: Vespidae). Mexico and South America

Rhinoceros beetle (COLEOPTERA: Scarabaeidae: Dynastinae)

Aztec wasp *Polistes carnifex* (HYMENOPTERA: Vespidae). Mexico and South America

Ten-lined June beetle *Polyphylla decemilineata* (COLEOPTERA: Scarabaeidae: Melolonthinae). United States

Robber fly (DIPTERA: Asilidae)

Bumblebee (HYMENOPTERA: Apidae)

Ground beetle *Ceroglossus chilensis gloriosus* (COLEOPTERA: Carabidae). Chile

Hornet (HYMENOPTERA: Vespidae)

Roundneck longhorn beetle *Trachyderes succinctus* (COLEOPTERA: Cerambycidae: Cerambycinae). Brazil

Scarab beetle (COLEOPTERA: Scarabaeidae)

The Garden of Earthly Delights (page 39)

top:

Stag beetle Chalcodes aeratus (COLEOPTERA: Lucanidae). Chile

Aztec wasp Polistes carnifex (HYMENOPTERA: Vespidae). Mexico and South America

middle:

Roundneck longhorn beetle Batus barbicornis (COLEOPTERA: Cerambycidae: Cerambycinae). Brazil

Leaf-footed bug Thasus gigas (HETEROPTERA: Coreidae). North America

Shining leaf chafer beetle Plusiotis aurigans (COLEOPTERA: Scarabaeidae: Rutelinae). Costa Rica

Roundneck longhorn beetle: Trachyderes succinctus (COLEOPTERA: Cerambycidae: Cerambycinae). Brazil

Metallic wood-boring beetle (COLEOPTERA: Buprestidae)

bottom:

Ground beetle (COLEOPTERA: Carabidae)

Rhinoceros beetle (COLEOPTERA: Scarabaeidae: Dynastinae)

2 Flower chafer beetles Ranzania splendens (COLEOPTERA: Scarabaeidae: Cetoniinae). Zimbabwe and Malawi

Little Time for Whimsy (page 41)

from left:

Flat-faced longhorn beetle Diastocera wallichi (COLEOPTERA: Cerambycidae: Lamiinae). Malaysia

Flat-faced longhorn beetle Dihammus australis (COLEOPTERA: Cerambycidae: Lamiinae). Papua New Guinea

Southwestern Hercules beetle Dynastes granti (male) (COLEOPTERA: Scarabaeidae: Dynastinae). United States

Rhinoceros beetle Allomyrhina dichotomus taiwana (female) (COLEOPTERA: Scarabaeidae: Dynastinae). Taiwan

Southwestern Hercules beetle Dynastes granti (female) (COLEOPTERA: Scarabaeidae: Dynastinae). United States

The Illusion of Orderly Progress (page 43)

Shining leaf chafer beetles Chrysina macropus (COLEOPTERA: Scarabaeidae: Rutelinae). Latin America

Am I Pretty? (page 45)

Metallic wood-boring beetle Julodis iris (COLEOPTERA: Buprestidae). Israel

Shining leaf chafer beetle Plusiotis gloriosa (COLEOPTERA: Scarabaeidae: Rutelinae). United States

Shining leaf chafer beetle Plusiotis aurigans (COLEOPTERA: Scarabaeidae: Rutelinae). Costa Rica

Flower chafer beetle Eudicella ducalis (COLEOPTERA: Scarabaeidae: Cetoniinae). Africa

Flower chafer beetle Ranzania splendens (COLEOPTERA: Scarabaeidae: Cetoniinae). Zimbabwe and Malawi

Flower chafer beetle Cheirolasia burkei (COLEOPTERA: Scarabaeidae: Cetoniinae). Republic of South Africa

Metallic wood-boring beetle (COLEOPTERA: Buprestidae)

Who Is the Fairest of Them All? (page 47)

Walkingstick Heteropteryx dilatata (ORTHOPTERA: Phasmatodea: Phasmatidae). Malaysia

"How's Yellow Eyes?" . . . (page 49)

top:

Planthopper Alphaema discolor nigrotibia (HOMOPTERA: Fulgoridae). Malaysia

Walkingstick Megaphasma denticrus (ORTHOPTERA: Phasmatodea: Phasmatidae). United States

Nut weevil Eupholus bennettii (COLEOPTERA: Curculionidae: Curculioninae). Papua New Guinea

middle:

Shining leaf chafer beetle Plusiotis gloriosa (COLEOPTERA: Scarabaeidae: Rutelinae). Costa Rica

2 Broad-nosed weevils Lamprocyphus germari (COLEOPTERA: Curculionidae: Brachyderinae). Brazil

Nut weevil Eupholus bennettii (COLEOPTERA: Curculionidae: Curculioninae). Papua New Guinea

3 Shining leaf chafer beetles Plusiotis gloriosa (COLEOPTERA: Scarabaeidae: Rutelinae). Costa Rica

Nut weevil Eupholus schoenherri (COLEOPTERA: Curculionidae: Curculioninae). Papua New Guinea and Indonesia

Nut weevil Eupholus bennettii (COLEOPTERA: Curculionidae: Curculioninae). Papua New Guinea

bottom:

3 Nut weevils Eupholus schoenherri (COLEOPTERA: Curculionidae: Curculioninae). Papua New Guinea and Indonesia

Ground beetle *Damaster blapoides montanus* (COLEOPTERA: Carabidae). Japan

2 Nut weevils *Eupholus schoenherri* (COLEOPTERA: Curculionidae: Curculioninae). Papua New Guinea and Indonesia

2 Shining leaf chafer beetles *Chrysina macropus* (COLEOPTERA: Scarabaeidae: Rutelinae). Latin America

Dance Betrayal (page 51)
Harlequin beetles *Acrocinus longimanus* (COLEOPTERA: Cerambycidae: Lamiinae). Latin America

Deception (page 53)
top:
Walking leaf insect *Phyllium gigateum* (ORTHOPTERA: Phasmatodea: Phyllidae). Malaysia
bottom:
Ground beetles *Damaster blapoides montanus* (COLEOPTERA: Carabidae). Japan

The Myth of Coupling (page 55)
top:
Shining leaf chafer beetle *Chrysina macropus* (COLEOPTERA: Scarabaeidae: Rutelinae). Latin America
middle:
2 Tooth-necked longhorn beetles *Psalidognathus friendi* (COLEOPTERA: Cerambycidae: Prioninae). Colombia
2 Metallic wood-boring beetles *Euchroma gigantea gigantea* (COLEOPTERA: Buprestidae). Latin America
2 Cicadas (HOMOPTERA: Cicadidae)
bottom:
Stag beetle *Chalcodes aeratus* (COLEOPTERA: Lucanidae). Malaysia
Short-horned grasshopper *Tropidacris dux* (ORTHOPTERA: Acrididae). Latin America

Saturday Night (page 57)
Harlequin beetles *Acrocinus longimanus* (COLEOPTERA: Cerambycidae: Lamiinae). Latin America

Mine (page 59)
Giant monkey spider (ARANEA). Malaysia

Real Estate (page 61)
Ground beetle *Damaster blapoides montanus* (COLEOPTERA: Carabidae). Japan

Flat-faced longhorn beetle *Rosenbergia weiskei* (COLEOPTERA: Cerambycidae: Lamiinae). Papua New Guinea

Nut weevil *Eupholus schoenherri* (COLEOPTERA: Curculionidae: Curculioninae). Papua New Guinea

The Crossing (page 63)
top:
Leaf-footed bug *Thasus gigas* (HETEROPTERA: Coreidae). North America
Ground beetle *Damaster blapoides montanus* (COLEOPTERA: Carabidae). Japan
Stag beetle *Hexarthrius vitallisi* (COLEOPTERA: Lucanidae). Vietnam
Short-horned grasshopper *Tropidacris dux* (ORTHOPTERA: Acrididae). Latin America
Tooth-necked longhorn beetle *Psalidognathus friendi* (COLEOPTERA: Cerambycidae: Prioninae). Colombia
bottom:
Metallic wood-boring beetle *Euchroma gigantea gigantea* (COLEOPTERA: Buprestidae). Latin America
Stag beetle (COLEOPTERA: Lucanidae)

Rain Follows the Plow (page 65)
top:
Nut weevil *Eupholus schoenherri* (COLEOPTERA: Curculionidae: Curculioninae). Papua New Guinea and Indonesia
middle:
Giant tailless whip scorpion (AMBLYPYGIDA)
Flower chafer beetle *Rhomborrhina splendida* (COLEOPTERA: Scarabaeidae: Cetoniinae). Taiwan
bottom:
Shining leaf chafer beetle *Chrysina macropus* (COLEOPTERA: Scarabaeidae: Rutelinae). Latin America

The Sense of Failed Expectations (page 67)
Giant Amazon ants *Dinoponera quadriceps* (HYMENOPTERA: Formicidae). Brazil

Short-horned grasshopper *Tropidacris dux* (ORTHOPTERA: Acrididae). Latin America

Katydid *Soliquifera grandis* (ORTHOPTERA: Tettigoniidae). Papua New Guinea

Heroes (page 83)

Rhinoceros beetle *Allomyrhina dichotomus taiwana* (COLEOPTERA: Scarabaeidae: Dynastinae). Taiwan

(on top) Ground beetle *Carabus cancellatus* (COLEOPTERA: Carabidae). Austria

(on bottom) Tooth-necked longhorn beetle *Psalidognathus friendi* (COLEOPTERA: Cerambycidae: Prioninae). Colombia

Flower chafer beetle *Euchoea desmaresti* (COLEOPTERA: Scarabaeidae: Cetoniinae). Madagascar

Justice (page 85)

top:

Nut weevils *Eupholus bennettii* (COLEOPTERA: Curculionidae: Curculioninae). Papua New Guinea

bottom:

Flat-faced longhorn beetles *Rosenbergia weiskei* (COLEOPTERA: Cerambycidae: Lamiinae). Papua New Guinea

Ship of Fools (page 87)

Flower chafer beetle *Euchoea desmaresti* (COLEOPTERA: Scarabaeidae: Cetoniinae). Madagascar

Cicada (HOMOPTERA: Cicadidae)

Walkingstick (ORTHOPTERA: Phasmatodea: Phasmatidae)

Flat-faced longhorn beetle *Rosenbergia weiskei* (COLEOPTERA: Cerambycidae: Lamiinae). Papua New Guinea

Ground beetle *Damaster blapoides montanus* (COLEOPTERA: Carabidae). Japan

Yet Another Postmodern Sunset (page 89)

Rhinoceros beetle *Allomyrhina dichotomus taiwana* (COLEOPTERA: Scarabaeidae: Dynastinae). Taiwan

Tiger katydid *Sanna intermedia* (ORTHOPTERA: Tettigoniidae). Malaysia

Walkingstick *Megaphasma denticrus* (ORTHOPTERA: Phasmatodea: Phasmatidae). United States

Harlequin beetle *Acrocinus longimanus* (COLEOPTERA: Cerambycidae: Lamiinae). Latin America

Short-horned grasshopper *Tropidacris dux* (ORTHOPTERA: Acrididae). Latin America

Walkingstick *Tagesoidea nigrofasciata* (ORTHOPTERA: Phasmatodea: Phasmatidae). Malaysia

Untitled (page 91)

Rhinoceros beetle *Allomyrhina dichotomus taiwana* (COLEOPTERA: Scarabaeidae: Dynastinae). Taiwan

Tooth-necked longhorn beetle *Psalidognathus friendi* (COLEOPTERA: Cerambycidae: Prioninae). Colombia

Yucatán scorpion (SCORPIONES). Mexico

Short-horned grasshopper *Tropidacris dux* (ORTHOPTERA: Acrididae). Latin America

Giant weevil *Macrochirus praetor* (COLEOPTERA: Curculionidae: Curculioninae). Malaysia

A NOTE ABOUT THE AUTHOR

Barbara Norfleet is the founder, director, and curator of The
Photography Collection at the Carpenter Center for the Visual Arts
at Harvard. She is the recipient of numerous awards from the
National Endowment for the Humanities, a Guggenheim Fellow,
and the author of, among other books, *The Champion Pig*, *Manscape with
Beasts*, and *Looking at Death*. She has had more than twenty solo shows
and innumerable group shows, and her photographs are part of the
permanent collection of virtually every major museum in America.

A NOTE ON THE TYPE

The text of this book is set in Monotype Joanna, a typeface
designed by Eric Gill, the noted English stonecutter, typographer,
and illustrator. It was released by the Monotype Corporation in
1937. Reflecting Eric Gill's idiosyncratic approach to type design,
Joanna has a number of playful features, chief among them the
design of the italic companion as a narrow sloped roman.

Composed by North Market Street Graphics,
Lancaster, Pennsylvania
Printed and bound by Tien Wah, Singapore